Is it the poet's soul, or every soul that wants to be formed for and baptized by the sea? Whatever the answer, Darren Demaree is such a soul, landlocked and longing, writing poetry as a "gut reaction" to unrequited need for language, like an ocean, to tide him under and take him away. Dare yourself to enter this *blue and blue and blue*, this "shuttle-/ shake to the eco-system,/ a dance almost/ & after a while/ of breathing."

KIMBERLY ANN PRIEST
author of *Slaughter the One Bird*

With short-syllabled lines that hint at an underlying need for control, these poems give us the ocean as a stage for a crisis of doubt and significance, for a speaker who watches a sunset and knows only that he has "nothing to do/ with the dawn." The ocean in Demaree's poems is curative, preservative, constant, indifferent, beautiful, wild, violent, and most of all, a mirror to the best and worst of humanity. In a world that wants us "to do/ grand things/ with a name," these poems examine how we remain a part of a larger song, an "all-rhythm" that is older and deeper than our own lives.

DONNA VORREYER
author of *To Everything There Is*

Darren Demaree's *blue and blue and blue* unfolds as the title does, suddenly and progressively, building one thing onto the next until we are saturated in blue, in the human condition, in the ego, in addiction recovery, in the small i of Demaree, which is a force so much like the ocean, the setting for these poems. Each small poem is just on the brink of bursting into this sea that moves back and forth in the rhythm of his lines, in their rejection of capitalization, and in their sparse punctuation. Demaree is a master at concentrated language that leaves space for the ephemeral. His voice is biblical and fragmented, reminiscent of the short dismantlings of Rae Armentrout and the soul searching and fracturing at the shoreline of Arnold's "Dover Beach." Each poem is a meditation that sets the mind spinning. In one poem, the speaker says, "i/ was so/ hoping/ to be baked/ into/ a world/ that would/ want to/ consume me." These poems threaten to consume the reader. I am still consumed and feel, after reading, that I was "forced to eat/ the endless horizon." *blue and blue and blue* is a masterpiece, both terrifying and comforting in all the ways poetry should be.

<div style="text-align: right;">

SARAH MOORE WAGNER
author of *Swan Life*

</div>

blue and blue and blue

Darren C. Demaree

Fernwood
PRESS

blue and blue and blue

©2024 Darren C. Demaree

Fernwood Press
Newberg, Oregon
www.fernwoodpress.com

All rights reserved. No part may be reproduced for any commercial purpose by any method without permission in writing from the copyright holder.

Printed in the United States of America

Cover art: Henrik Dønnestad via Unsplash
Author photo: Julie Rae Powers

ISBN 978-1-59498-133-3

The book is dedicated to my son, Thomas, my favorite person in the world to fight the waves with.

contents

i was perfect ... 9
if the soul ... 10
there is language 11
summer mirror .. 12
i was .. 13
i smell the salt ... 14
nothing else .. 15
it's a deep barrel 16
obsessive boneshaker 17
the edge ends ... 18
i am thinking .. 19
no green skim .. 20
all these birds ... 21
unless you are born 22
the apple myths 23
bouncing in my own blood 24
wrong inside .. 25
as a young man 26
the whole ... 27
despite the ceaseless 28
not a liar .. 29
i watch the whole 30
only the brain ... 31
i don't wait ... 32
hip-deep in the relative 33
hold the almonds 34
i have felt .. 35
the first tongue exploded 36

the city is	37
the transit is	38
i knew all of the names	39
atypically aimed	40
something exists	41
immersed in the salt	42
the light	43
bare bulb	44
& my art will be	45
i stepped into the ocean	46
pink to red	47
i want the mist	48
so many bodies	49
the floor is filled	50
a man becomes	51
each shell a piano key	52
outside of the water	53
what	54
nothing moves	55
how useless	56
how brief	57
fists curled	58
the sea has come	59
a good wave	60
all resolution	61
irreversible	62
the goal	63
spoken plainly	64

i was perfect-
ly weighted
to be taken

into the sea,
to make
the all-rhythm

my own true
nature, to be
lost between

the odd loves
of the world,
but by the end

of each day
i was placed
on the shore

amidst bound-
aries so un-
tender to me

if the soul
could hold
muscle

the same way
my shoulders
do, i would

be fearless
& constant
without

there is language
in every silence

summer mirror,
so iconic
in the mapping

of our fullness
that your phil-
osophy breeds

a fat, naked
culture, i see
how thick you

are beneath
this thin, roll-
ing wonder,

i see your map-
ping above
the skeletons

i was
born far
enough

away
that i
believed

you had
control
of your

tongue;
how ugly
it slaps

against
& over
the tide

while i
attempt
to dream

of hold-
ing
anything

at all

i smell the salt
i taste the salt
i do not move

i am kept meat
wanting to be
kept forever?

nothing else
has an architect;
this constant

has folded us
into what
it wanted

us to be
& if i walk away
now, i will be

going nowhere
untouched,
so i sit

& stare
until the blinking
makes me

feel so weak

it's a deep barrel
rolling onto our toes
& rolling away

to gain more
momentum
& i am here, on

the edge of violence
to prove that
my death will not

make me a victim
of anything other
than living my life

obsessive boneshaker,
this skin is my skin
& i can take your dance

for a long-ass time
& i don't need control
to find a little bit of joy

the edge ends
here; that is
so comforting

i am thinking
of the indigo
inking

that i had
traced over
my right rib-

cage, how much
that hurt me
& how loving-

ly i chose
such a color,
how worth it

it was
to choose
the smallest

piece
of forever
my nature

no green skim,
no belief
that the calm

within
is a natural
occurrence

& so, all of this
& all of this
& all of this

all these birds
want is the fish
meat

& they only know
how to open
their mouths to eat

or to ask to eat
more, they have
no songs

& they hear
no songs
& they're watching

me like i might
have an answer
for why

unless you are born
on the ocean,
you must leave

behind almost
all of the people
you know to live

on the ocean;
some are not people
without the ocean

the apple myths
don't matter
near the riptide

bouncing in my own blood
tunnels, i counted the ghosts
coming in from the cold sea

& i welcomed the ghosts
coming in from the cold sea
& even though i am their red

son, i knew they were not
an evil arriving, i knew
they were a sign of hope,

i knew they meant to show
me that a desperate man
can be desperate forever

& though that cannot be
a rallying cry for the still
& lovely, it released me

from my perch in the dunes

wrong inside
& kissed
at the bottom

of the dunes,
i have offered
the slight tide

my first ashes
& it wants
nothing to do

with my pride

as a young man
i preferred flowers
& i was wrong

to think the weed
of any moment
was worthless

to my pursuits
& now, as a young-
ish man, i spend

most of my time
holding up
thieving roots

& convincing
the faceless sea
that they're beautiful

the whole
ocean

& i am
dry as flour;

i was so
hoping

to be baked
into

a world
that would

want to
consume me

despite the ceaseless,
i look for faith
in all that can cease

not a liar
& not
a stillness,

this
arrival
of broken

lights
ground
into sift

& piling
is a world,
a reality

i watch the whole
sunset
& i am quite sure

that i can be
the sunset, which
really only confirms

that i have
nothing to do
with the dawn

only the brain
can be a hammock
for the soul

& since the tongue
might as well be
a series of ropes,

i have been quiet
for a long time now,
i have been

enjoying the tight-
ness, the slow strain
against the tether

which keeps me
here, believing
in here now here

i don't wait
for the lamb
to cool

& i don't wait
for the sea
to invite me

hip-deep in the relative
safety, i am forced to eat
the endless horizon

& when i become full,
i am forced to question
the meaning of sustenance

& decide whether or not
i am to lick this plate
clean, become so connected

that i exist in the narrative
of the ocean only, that i
become the indirect hero

whose name is said only
when all of the names
are spoken out loud

hold the almonds
in your fist
& when you've lost

all of them,
say a prayer to
the ocean's bottom

& make a promise
to lose the rest
of your fist as well

i have felt
otherwise
& i have

left the ocean
before,
but not again

& not again
& not again
will i divorce

my body
from the rest
of the bodies

the first tongue exploded
& gave us this sea
& i can't stop

that from feeling
directly like a challenge
to my own work

the city is
behind me

the transit is
behind me;
i am delivered

& i cannot
stroke the torrent
of the tide

without losing
both of my hands
& maybe

i could do
better without
these hands

& maybe,
the twin cities
of my world

would find
a natural rhythm
that way

i knew all of the names
that belonged to me
until i realized i belonged

to the ocean, that my body
which does such a poor job
holding my soul upright,

was meant to relent
amidst the true beastings
that belong here, now

& all of those names
i earned in pursuit of own-
ing better names, they

were sand to begin with

atypically aimed,
i may be an arrow,
but i hold no target

long enough
to be considered
a good weapon

& i am never
in the air long enough
to be any kind of bird

something exists
& even if it's not me
that truth is enough

of a fuck-around
to keep me looking
at the mechanics

of this shallow bit
of an ocean that goes
deeper than I can

immersed in the salt
water you begin
to forget the individual

waves, you begin
& end by counting
the shadows that reach

the water (zero)
& that number fits,
hits you in each lung

& to breathe through
all of that sunlight
& all of that water,

you play a little game
where each breath moves
the world a little bit,

gives a little shuttle-
shake to the ecosystem,
a dance almost

& after a while
of breathing only
you forget the ocean

the light
un-funneled
bellows

& since i
am amidst
the song,

i, need-
lessly join
the chorus

bare bulb
of the crush-
ing pocket,

i have been
drunk enough
to name you,

but i don't
remember
any of those

names
& i don't know
how many

drinks it took
to get me there,
where i thought

i could be
thankless enough
to own the sea

& my art will be
as a naked man
shoulder deep

in the ocean
& my art will be
losing the name

i was given
by parents
that wanted most

for me to do
grand things
with a name

& my art will be
vanishing amidst
the all-energy,

shoving it along
with a song
forgotten

i stepped into the ocean
& i left no footprints
in the ocean;

i'm from ohio,
i'm too used to the weak-
ness of snow,

i'm used to leaving
my mark
& I'm used to that mark

disappearing in the spring,
but this froth cared
nothing for my weight

pink to red
& out
of breath,

i love
that the ocean
never lies down

& that i can
never lie down
in the ocean

i want the mist
because i can
understand

the mist, i can
see the force
that creates it

& i can love
the before
even more

when the mist
finds my face
& it doesn't matter

how many bones
i don't see float
amidst the water

while it fire-
works so gently
in the air

so many bodies
unknowingly

epic in their
slight burials

the floor is filled
& the air is filled

& yet, we build
so many ceilings

a man becomes
less
& more than

a man when
he is swallowed
appropriately

by the never-
ending
uselessness

of a man
considering what
it is to be a man

each shell a piano key
pounded off the board
& i collect to hold them

to play them like the music
was my idea in first place,
like i was the pump

that provided all this water
& i was the conductor
that destroyed the songs

so i could save the songs
in my own image
& if it works,

i get to become the sea?

outside of the water
i am all braces
& healing balms

& though my body
has found all
of the places

of no return, my mind
knows that it's not
healing i come here

for, my mind knows
it's the all-rhythm
i want to tune

my soul with,
so that i can lose
my soul with purpose

what
ugliness?
what

nation?
i am hip
deep

in actual
answers
& these

are your
questions?
i am lost

in answers
& you
want to

bring
me back
to you?

nothing moves
on
& yet, i am

dragged
further out
towards

the most
nothing
we can allow

to move
away from
the bluelet

scarring
we claim
protects us

& because
i never
feigned

to be home
in sand,
i am home

beneath this,
the breaking
of the sun

how useless,
the shadows
in the surf

& yet I leap
toward the sun
like it could be

a cherry stem
that holds all
of the cherries

& when i see
my own
descending

it matters more
to me than
my efforts

& if i could once
leap without
watching myself

leap, i might
return to the blue
water with a prize

how brief
the pluck
& the never

mind of how
can i turn
this into song

that passes
as a wasted
moment

& again,
again, the bronze
failings of art

in such
an active,
ornery world

fists curled
& uncurling
beneath

the surf,
i am able
to gather up

the whole
of the swelling
world in

my hands
& release it
like i never

held it,
because i
never did hold

it long enough
to be more
than an object

amidst a world
made to bury
all objects

the sea has come
to harvest me
& that is a religion

for any moment
& that is exactly
why i have removed

my jacket, shown
my circus skin
to the moon's eye,

that is why
i am quiet when
my name is called

a good wave
knocks every pill
out of your pocket

all resolution
& violent
delivery,

the circles
that arrive
fully formed

are all promises
of an ending
& that miracle

is as precise
as a billion
breakings

can be,
that miracle
must be

translated
by those of us
in the pile

irreversible
& repeating,
i've stripped

off my clothes,
i've questioned
my own skin

& yet, every time
i hear my name
from the shore

i turn my head
away from
the blue

& the blue
& the blue
& that gut

reaction to
my equal word
in the chorus

removes
the adjustments
i most wanted

the goal
is to keep
failing;

the effort
is the most
i can

promise
to this
burning

between
the world's
deep eyes

spoken plainly,
the all-rhythm
doesn't include

my body
in the ocean,
but it does

include pledges
of mine to
disappear clean

near my own land
& to have
my own name

carry only
the weight
of a syllable count